Love Coloring Book

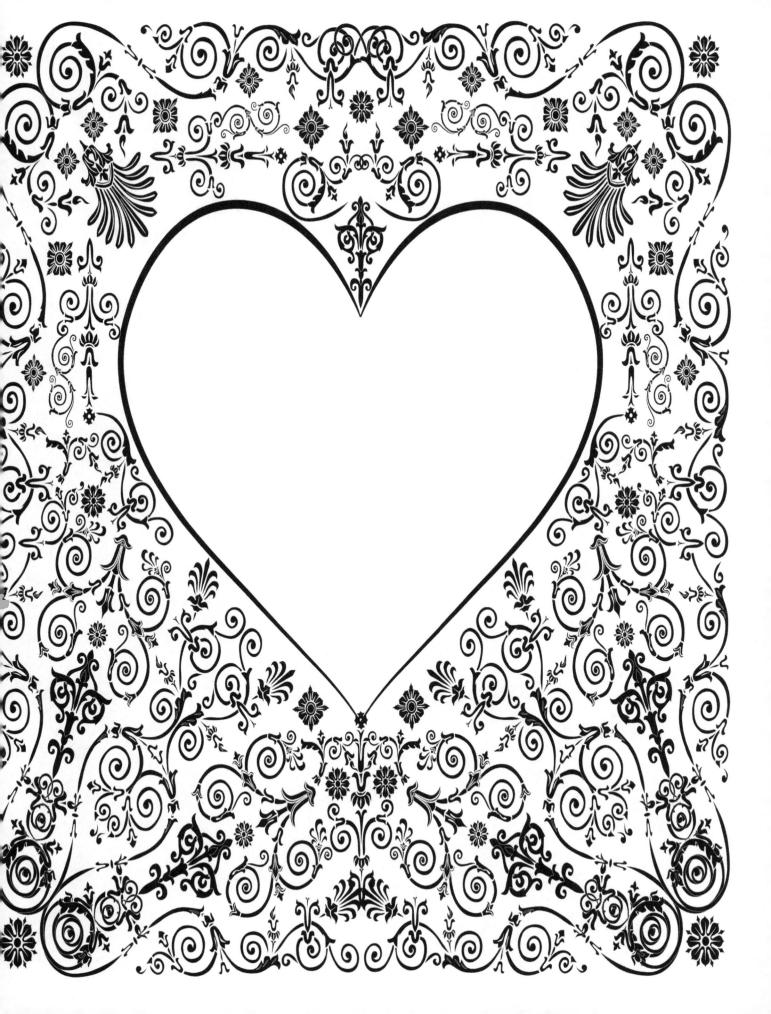

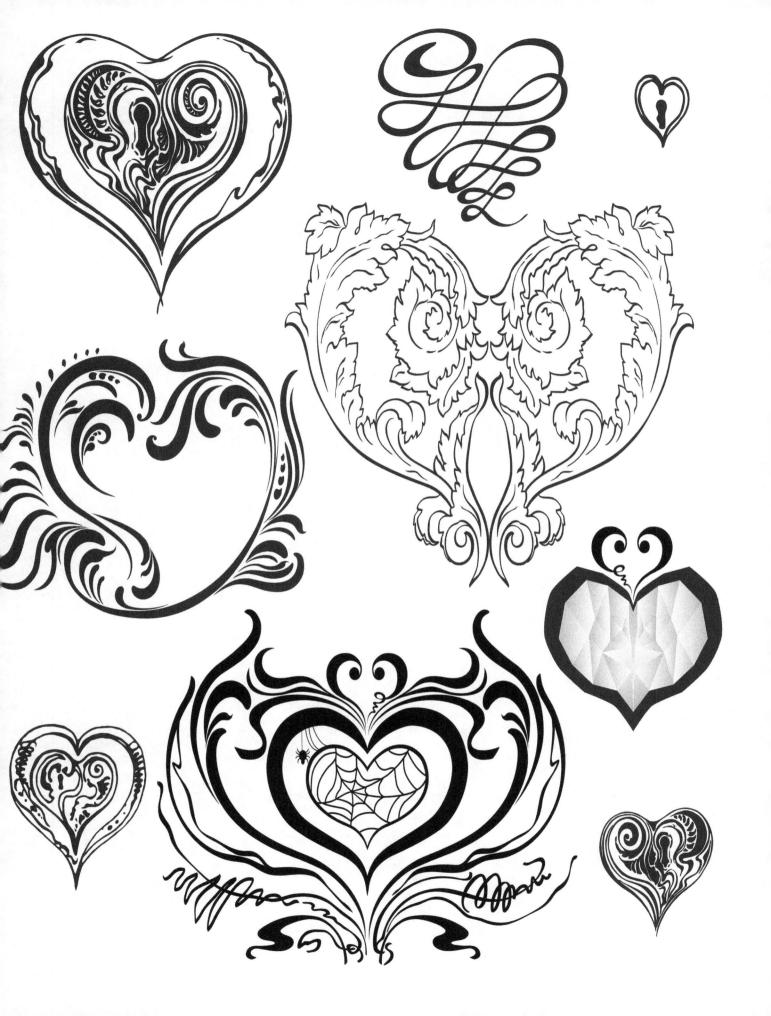

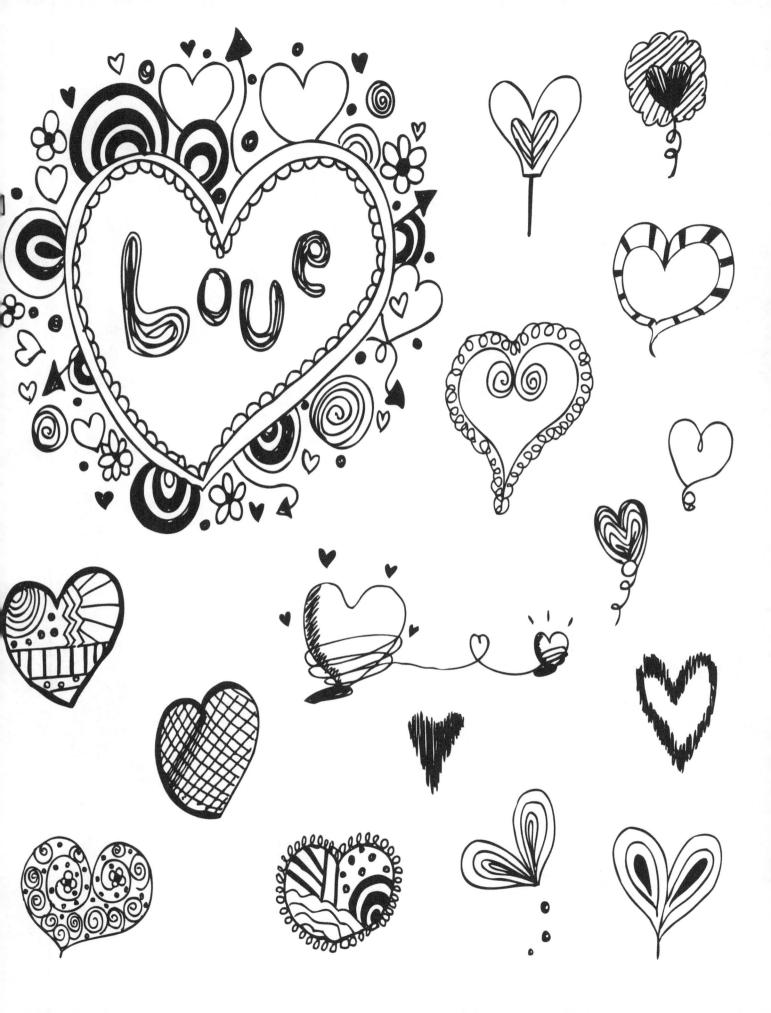

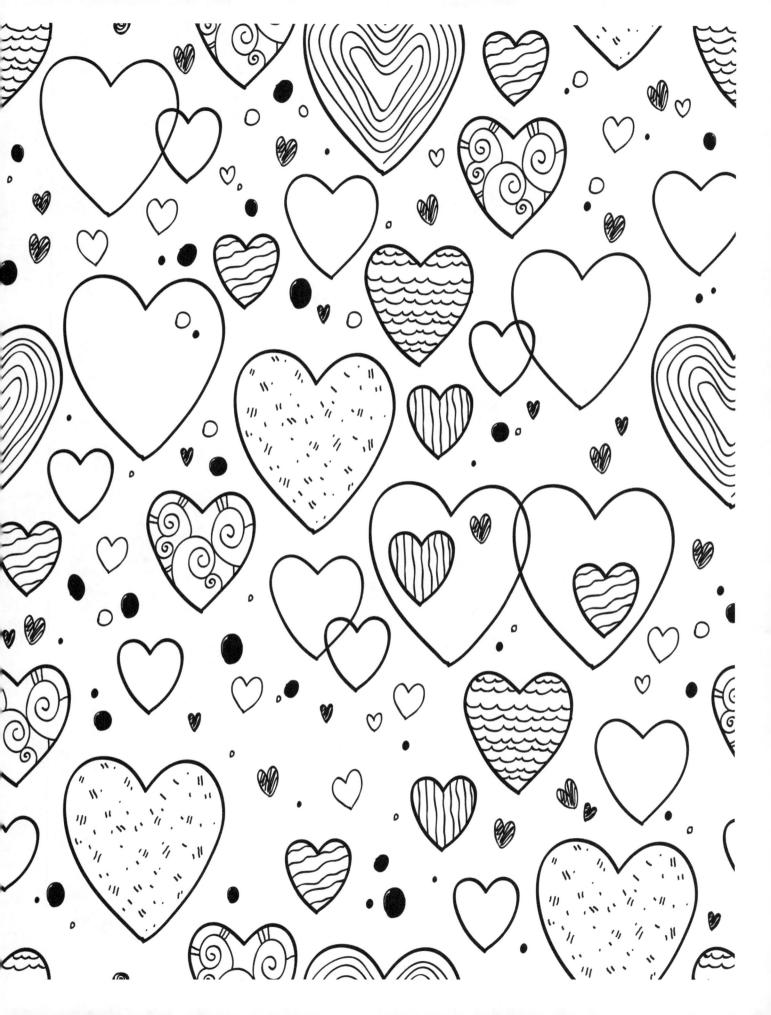

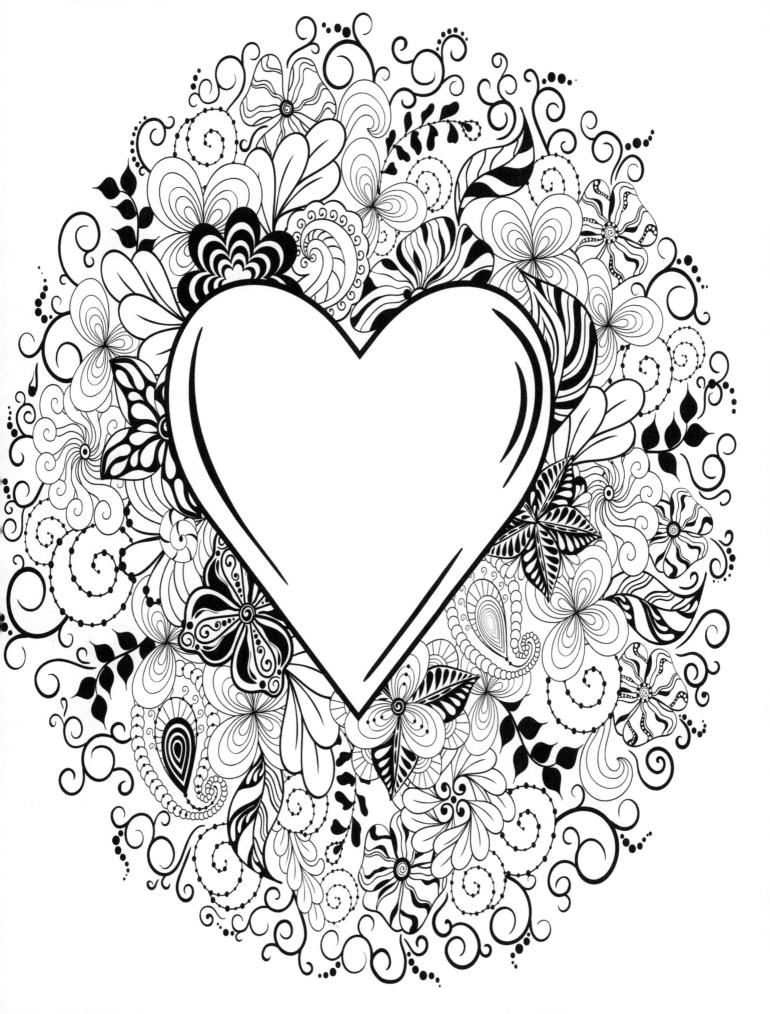

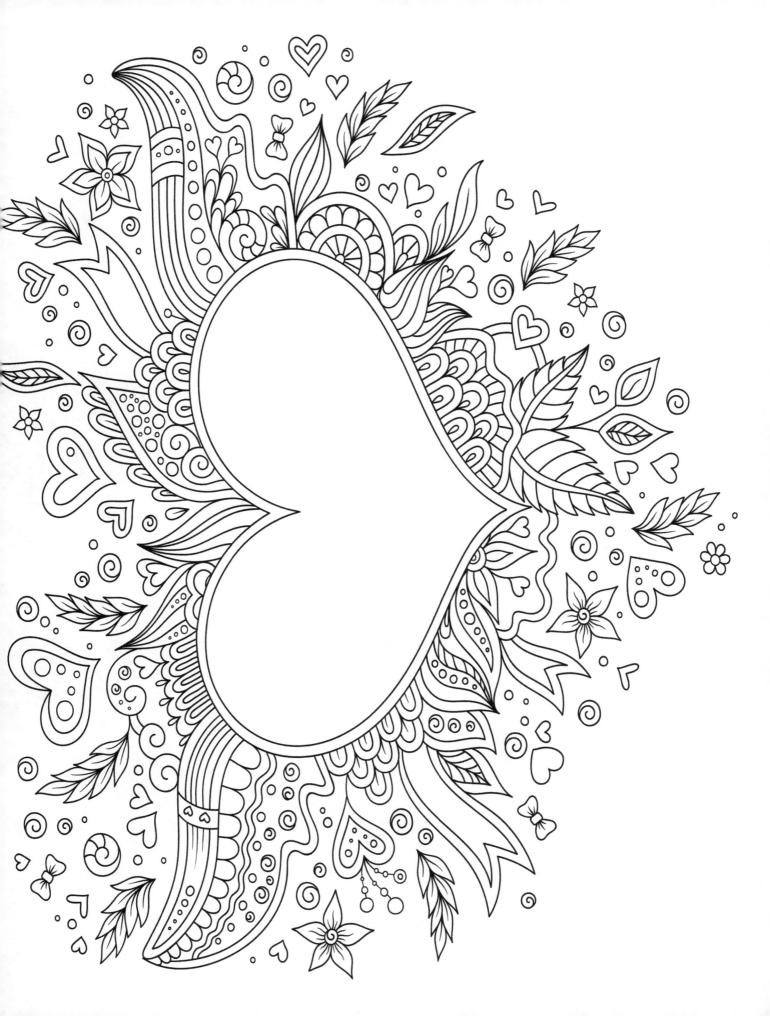

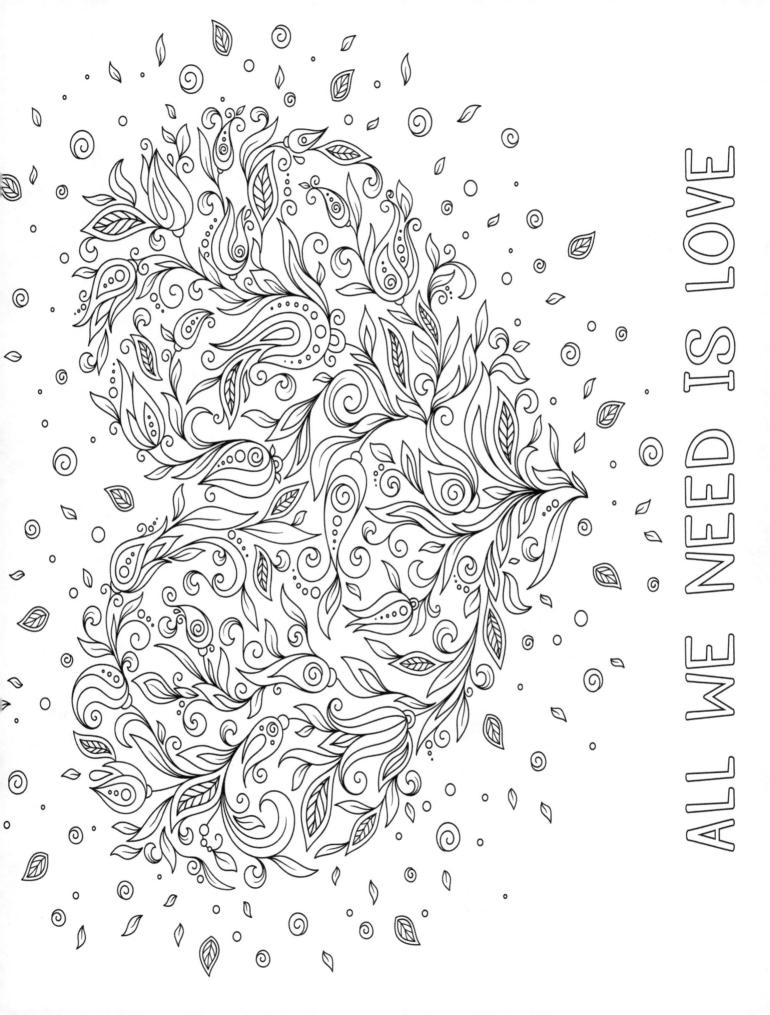

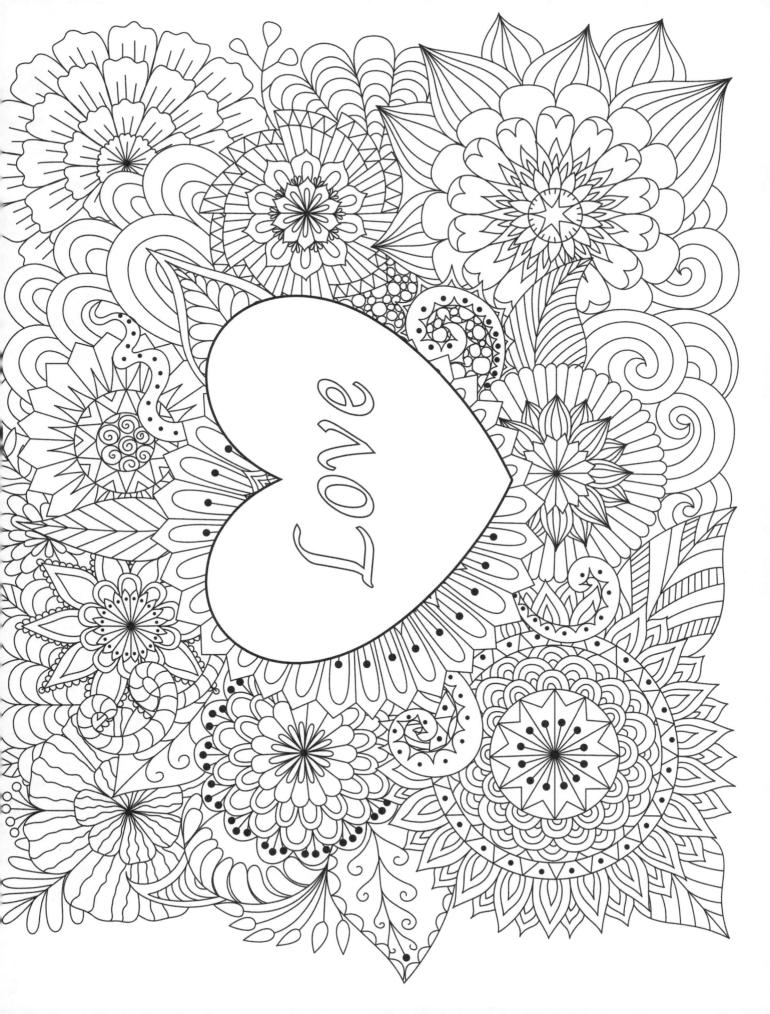

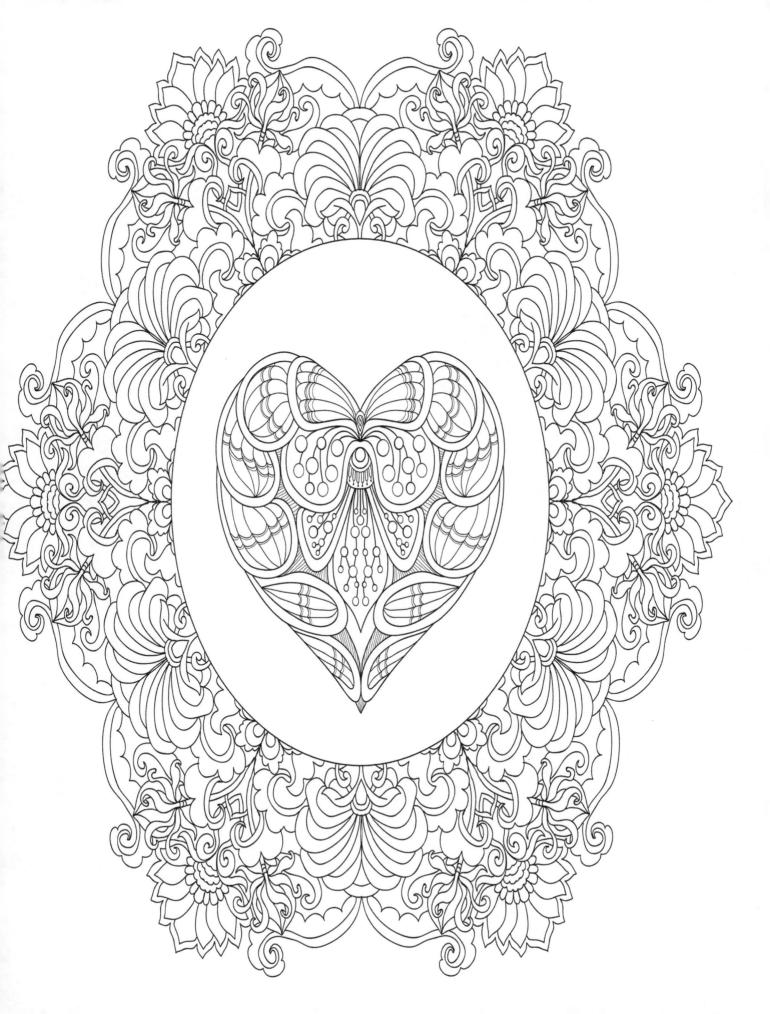

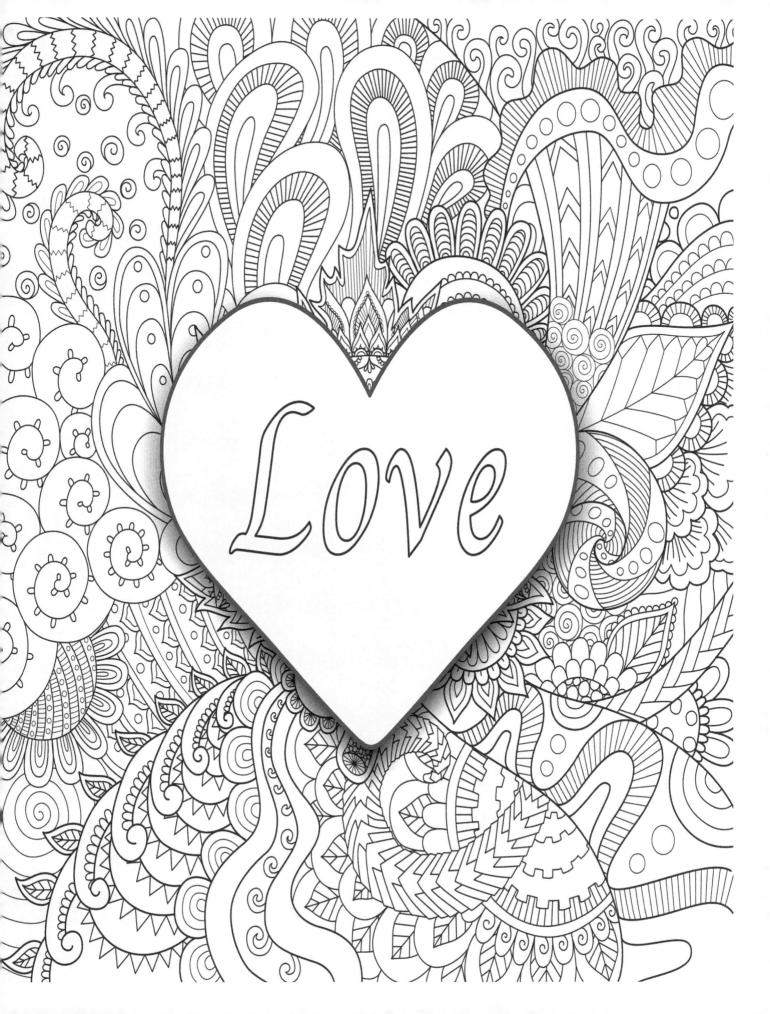

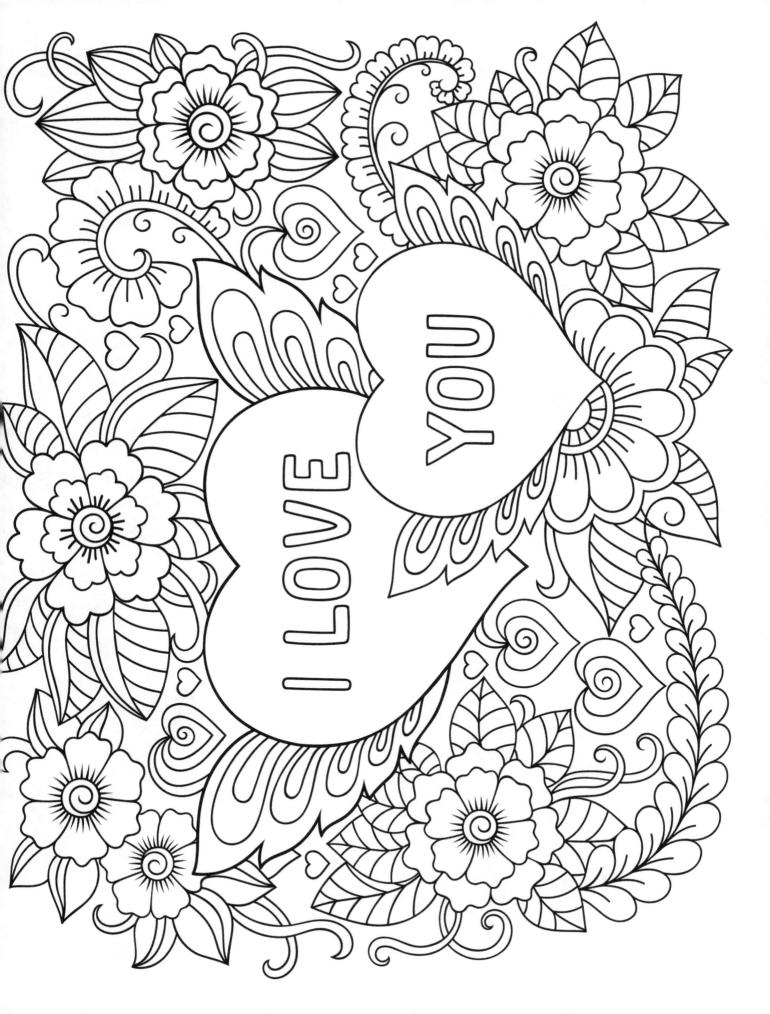

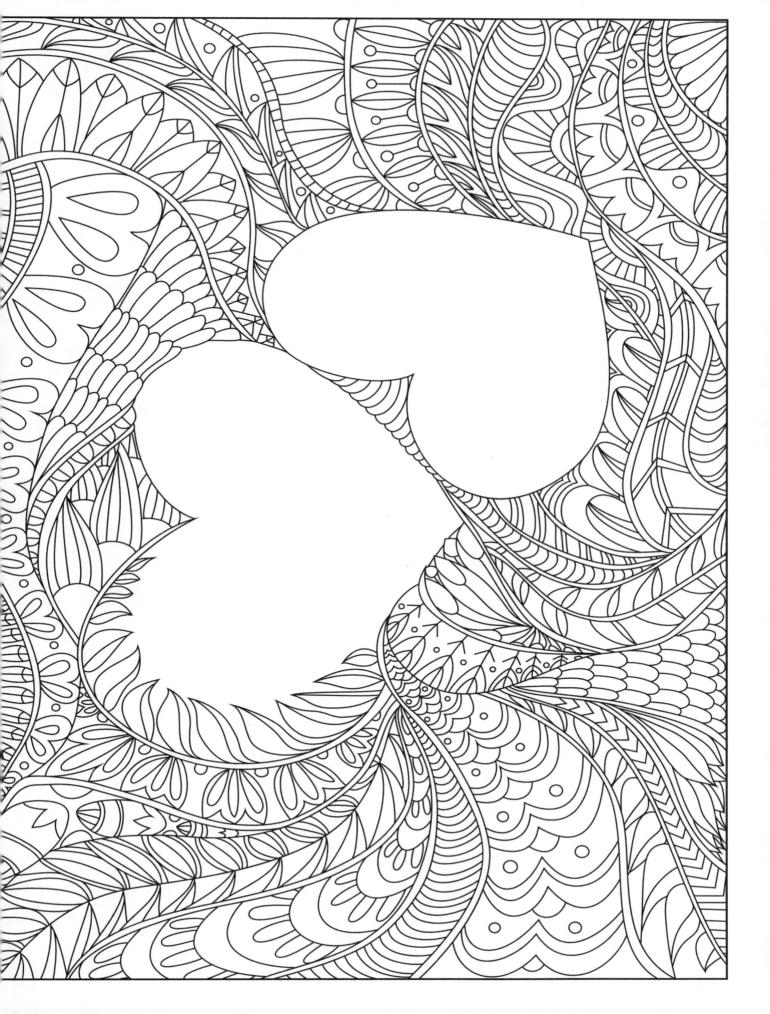

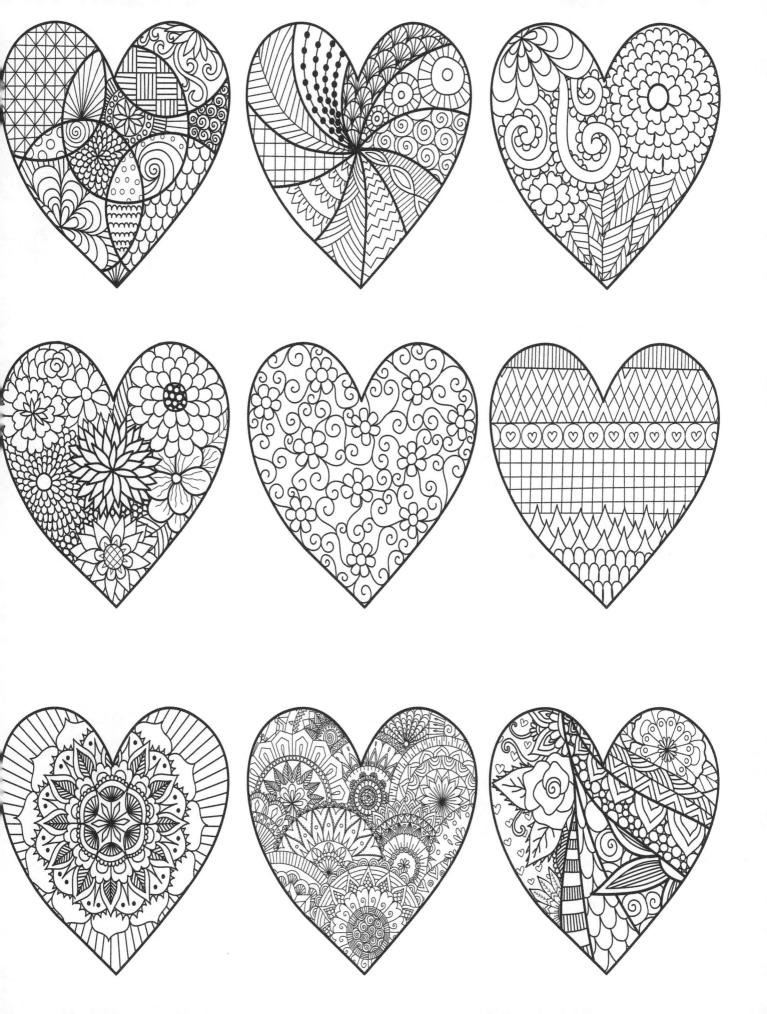

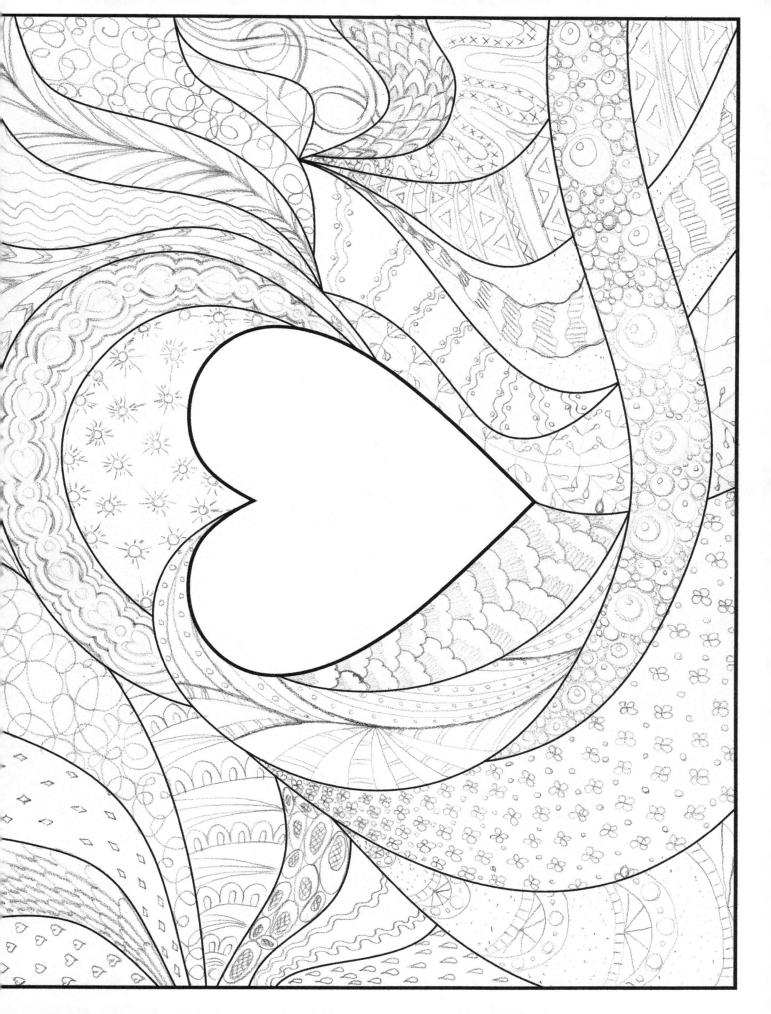

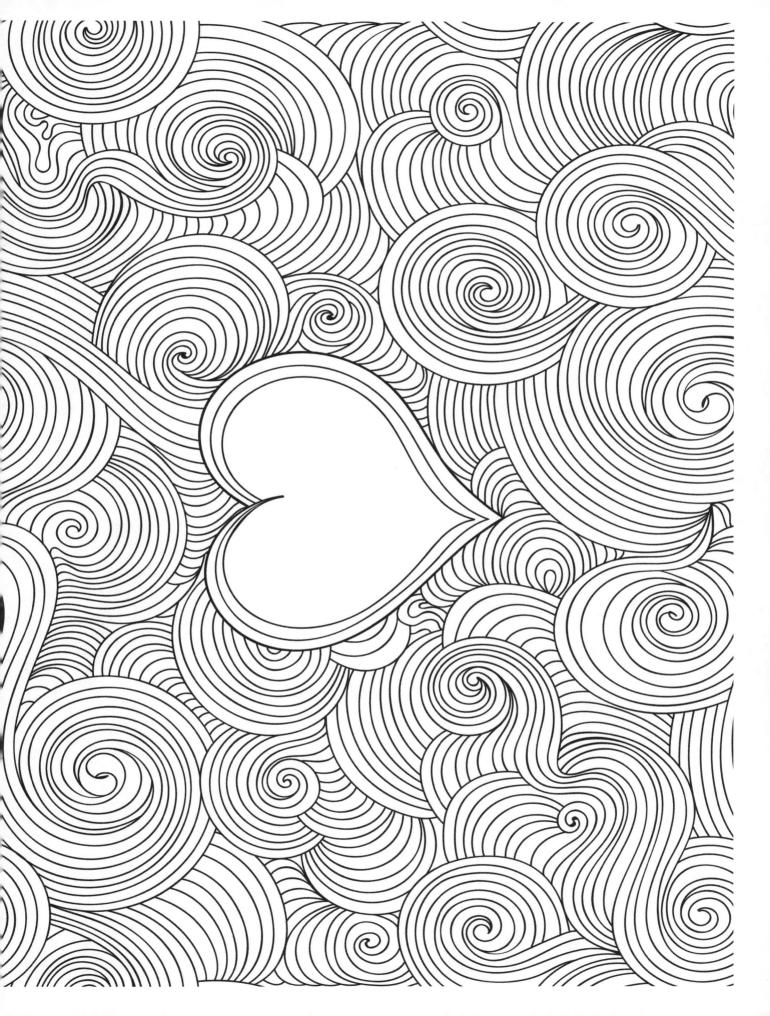

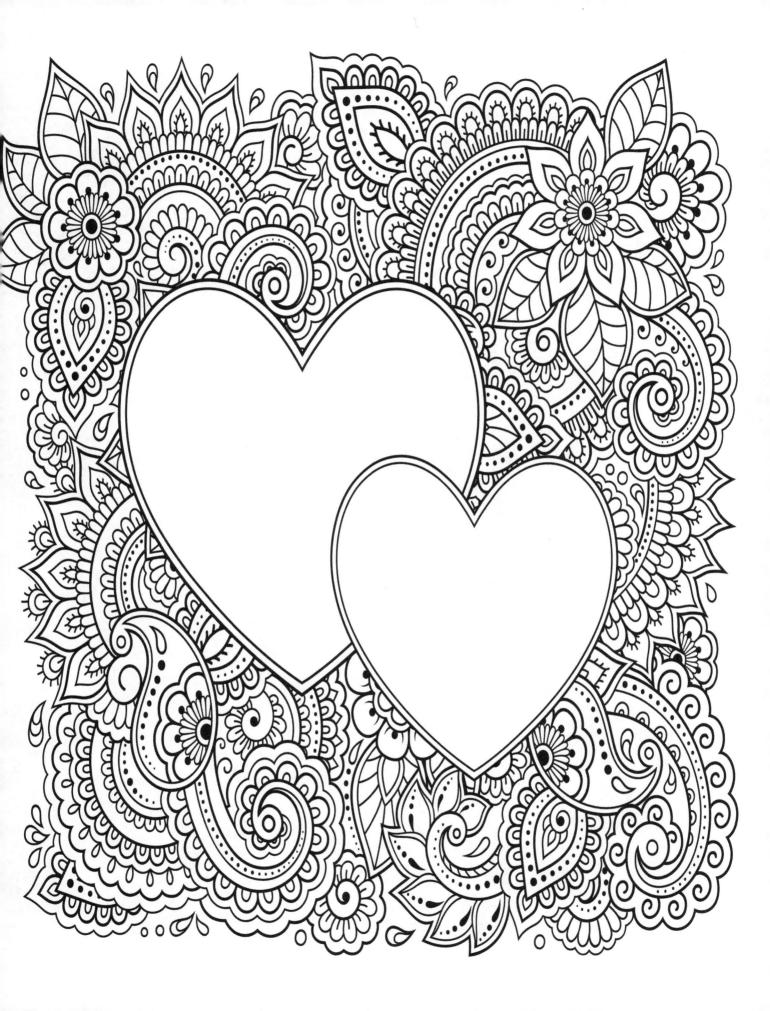

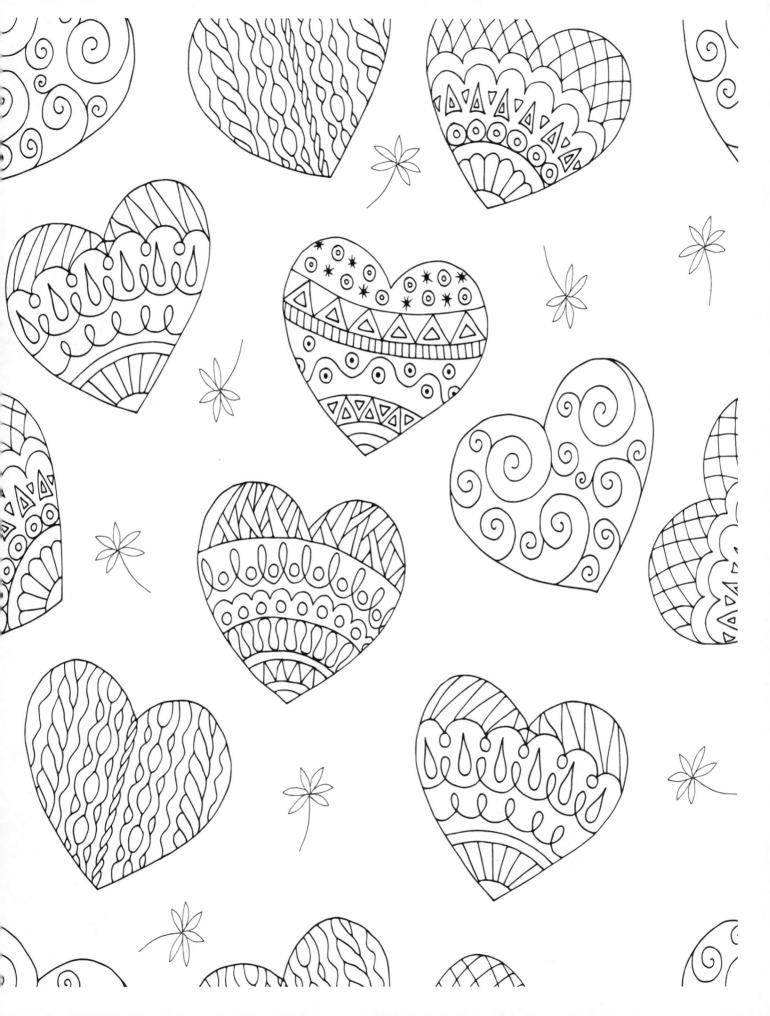

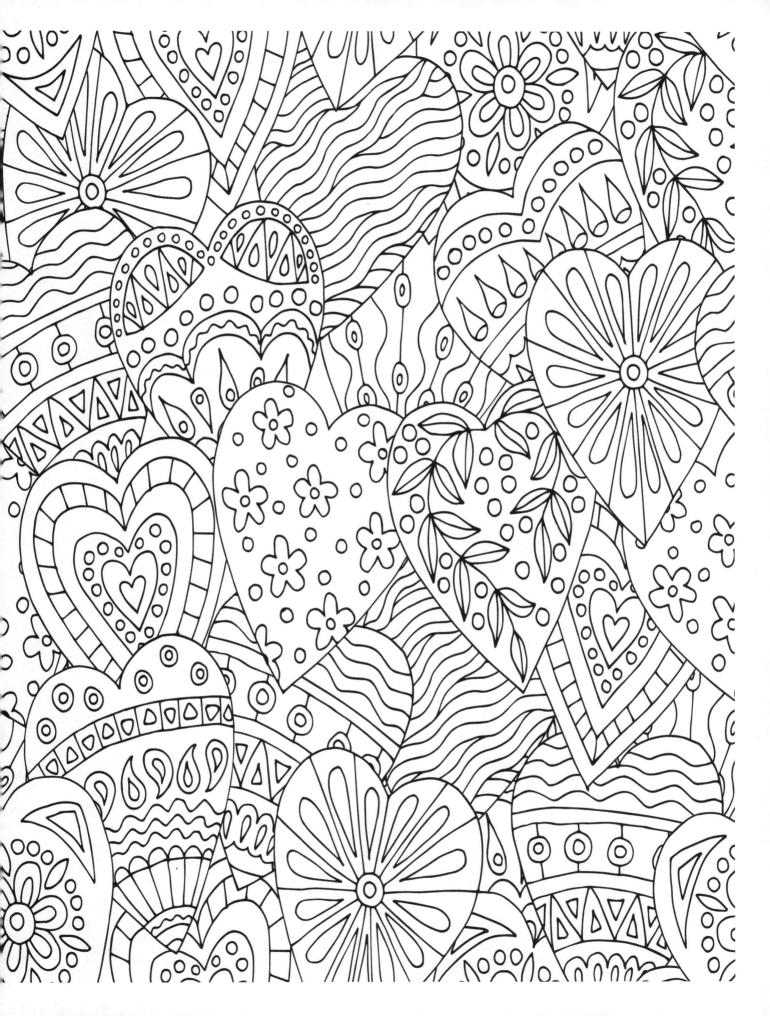

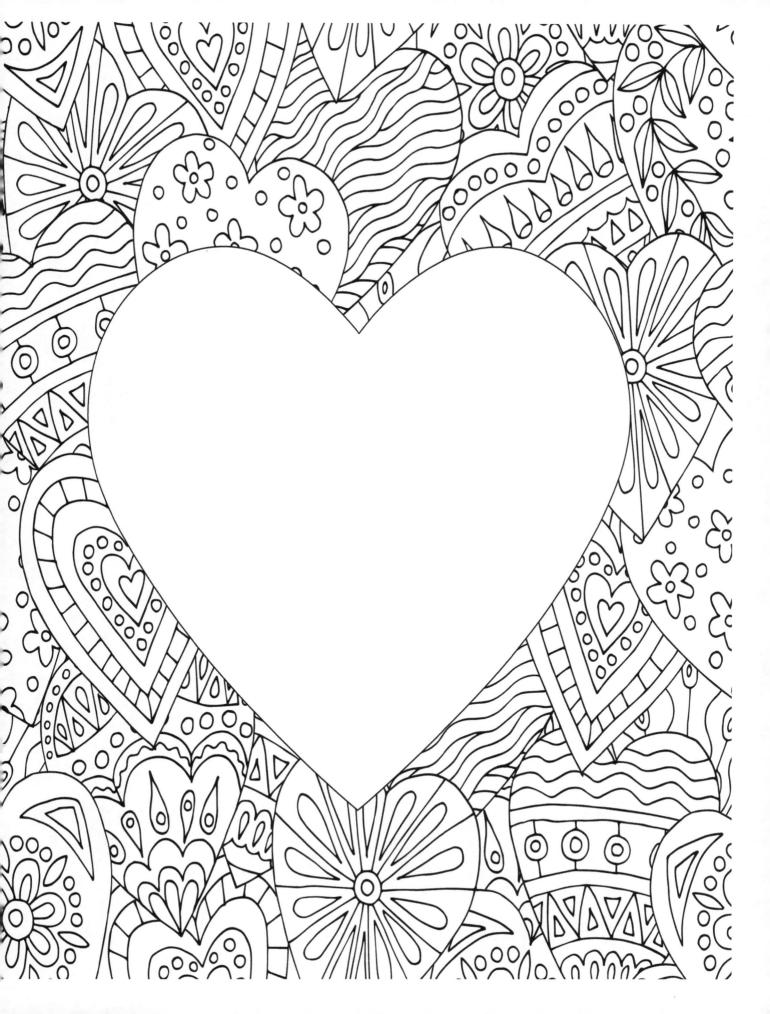

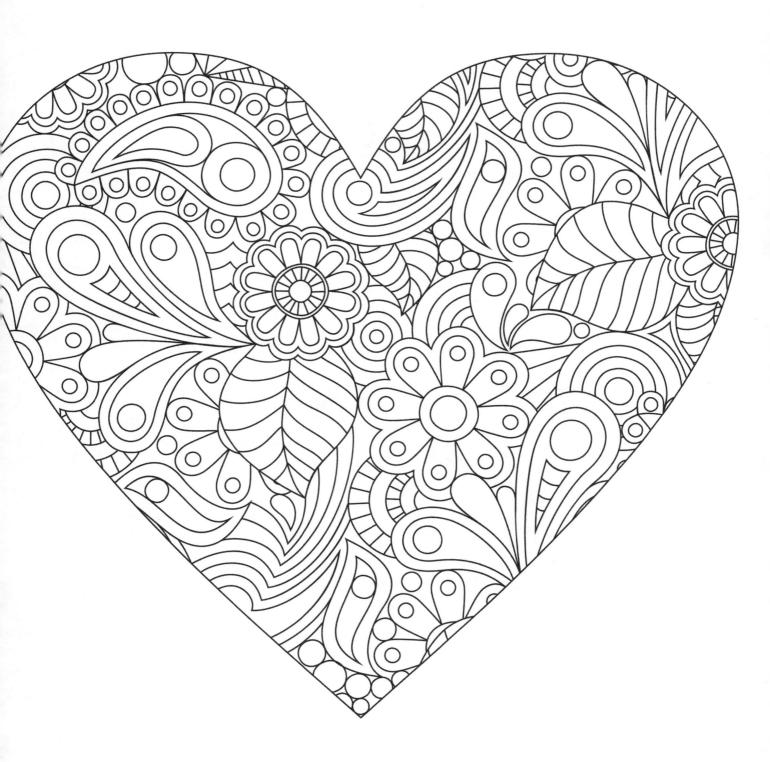

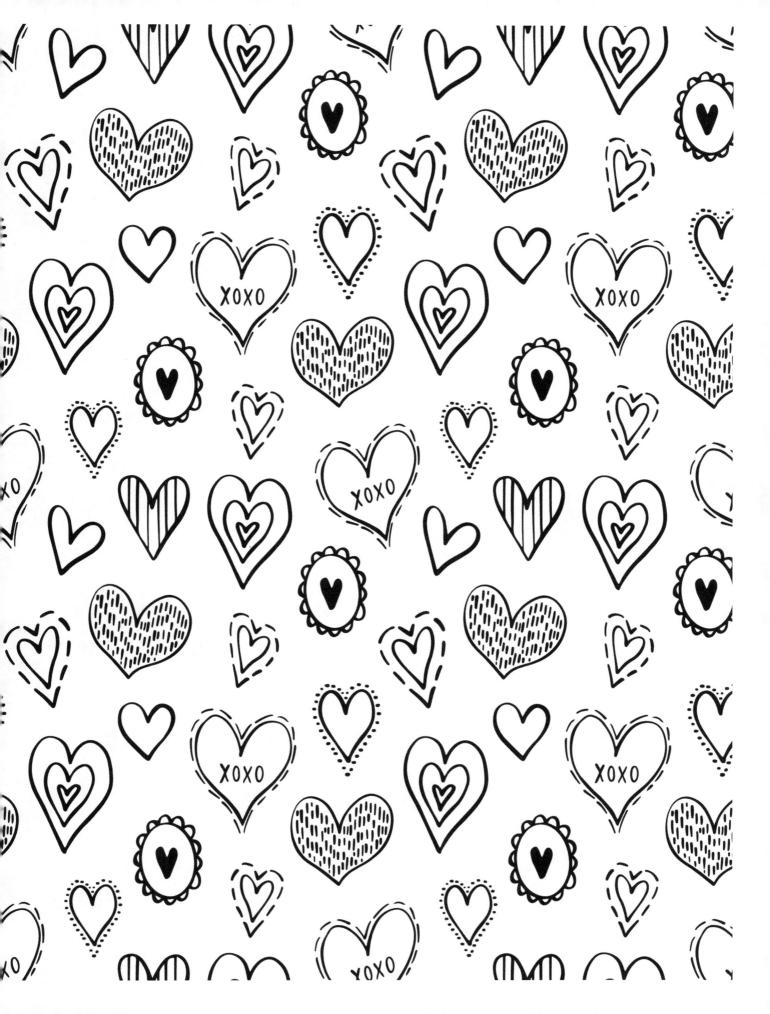

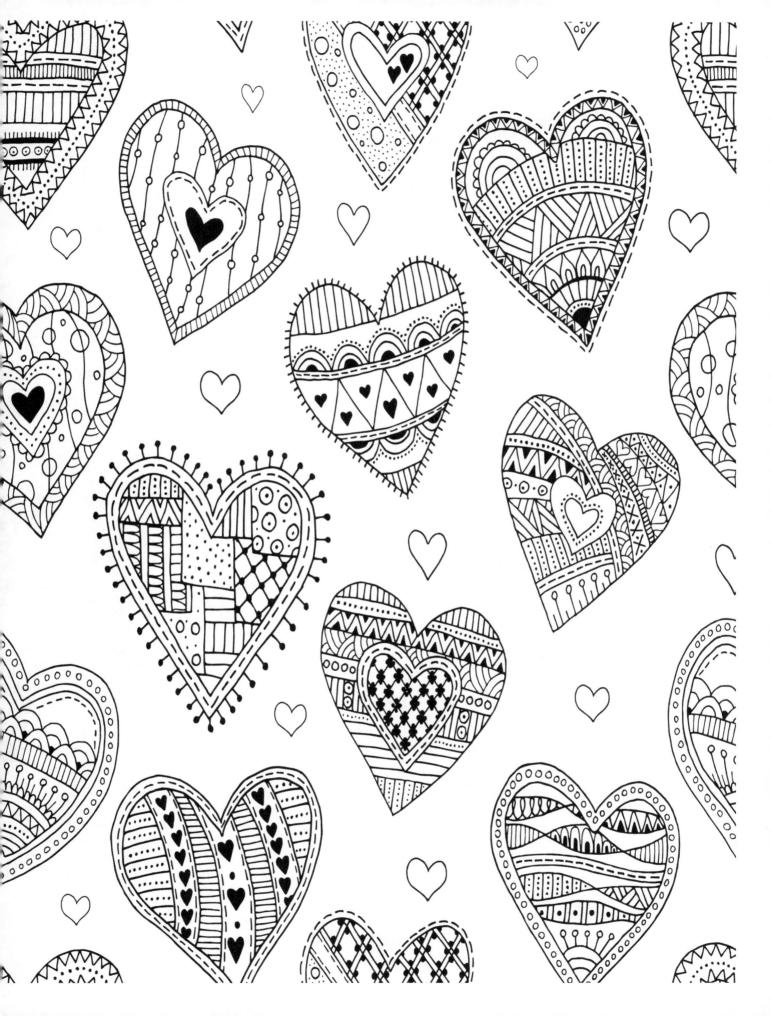

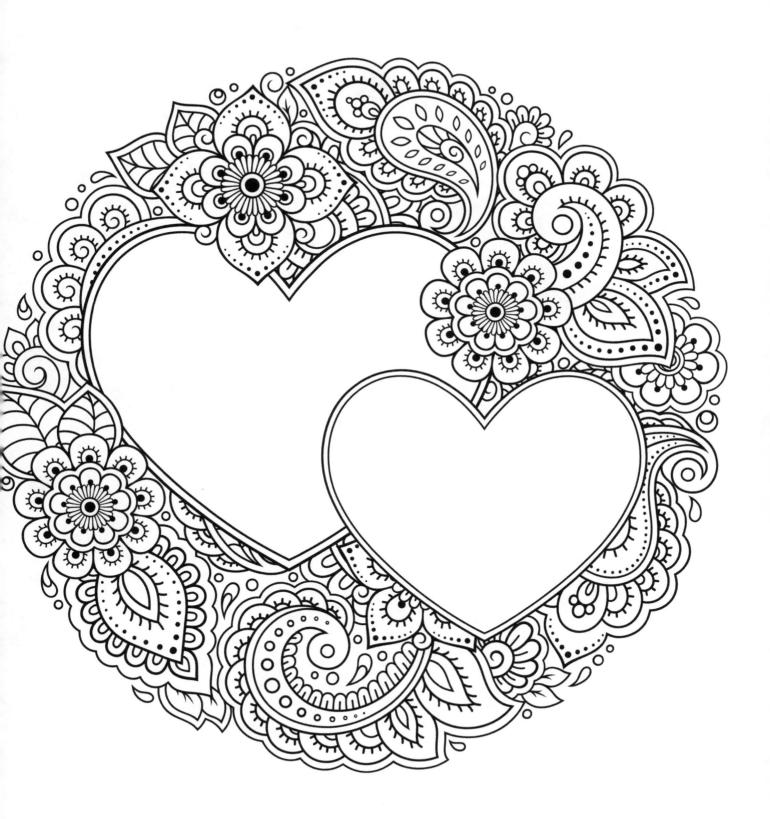

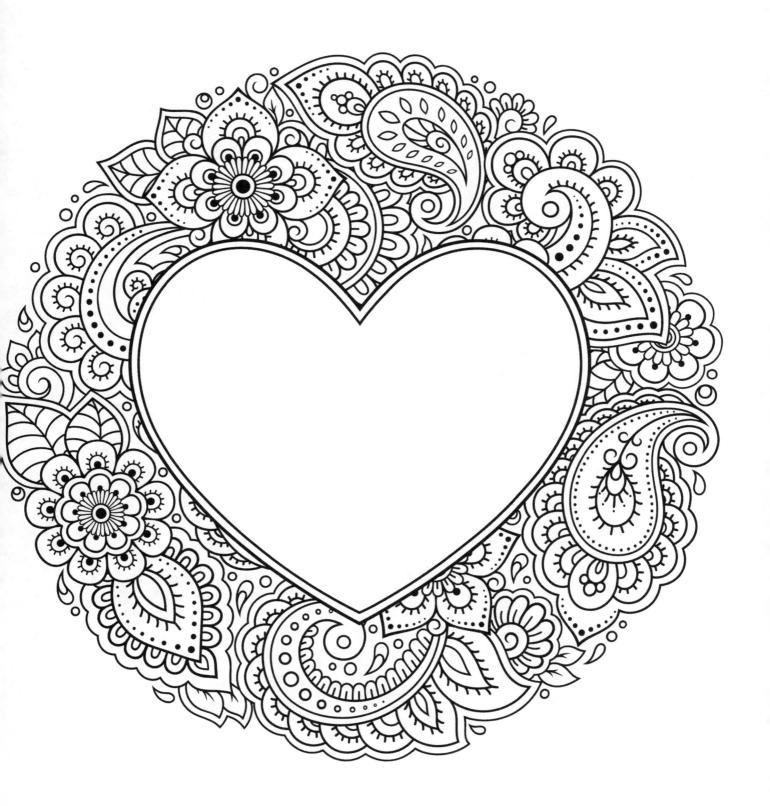

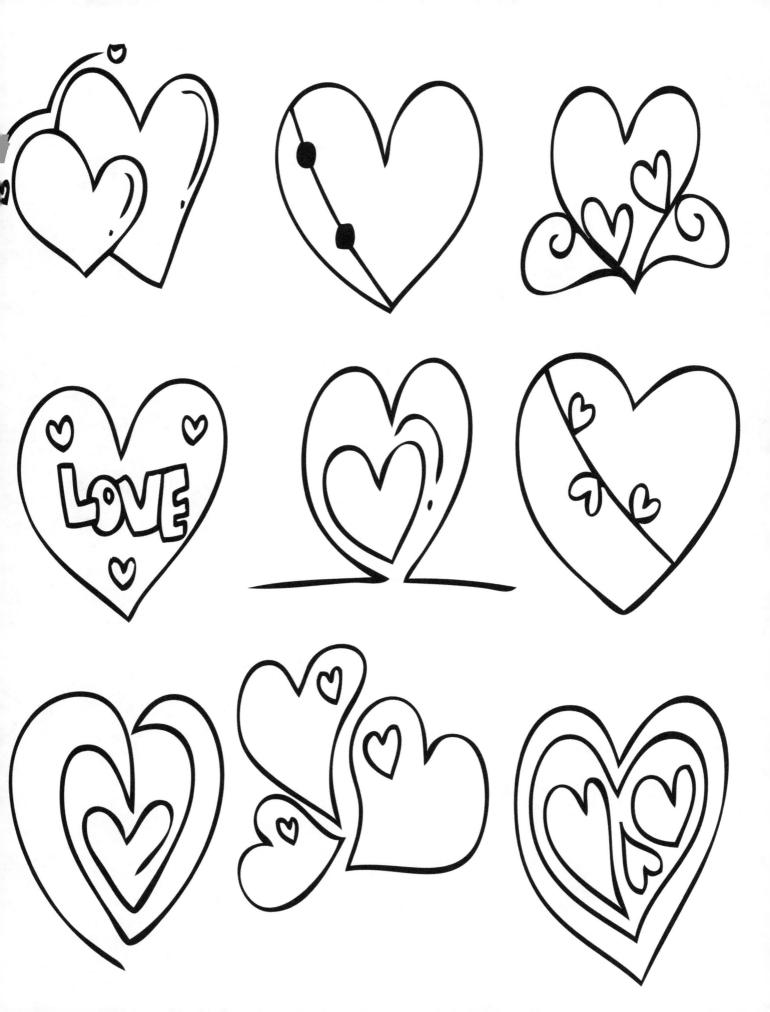

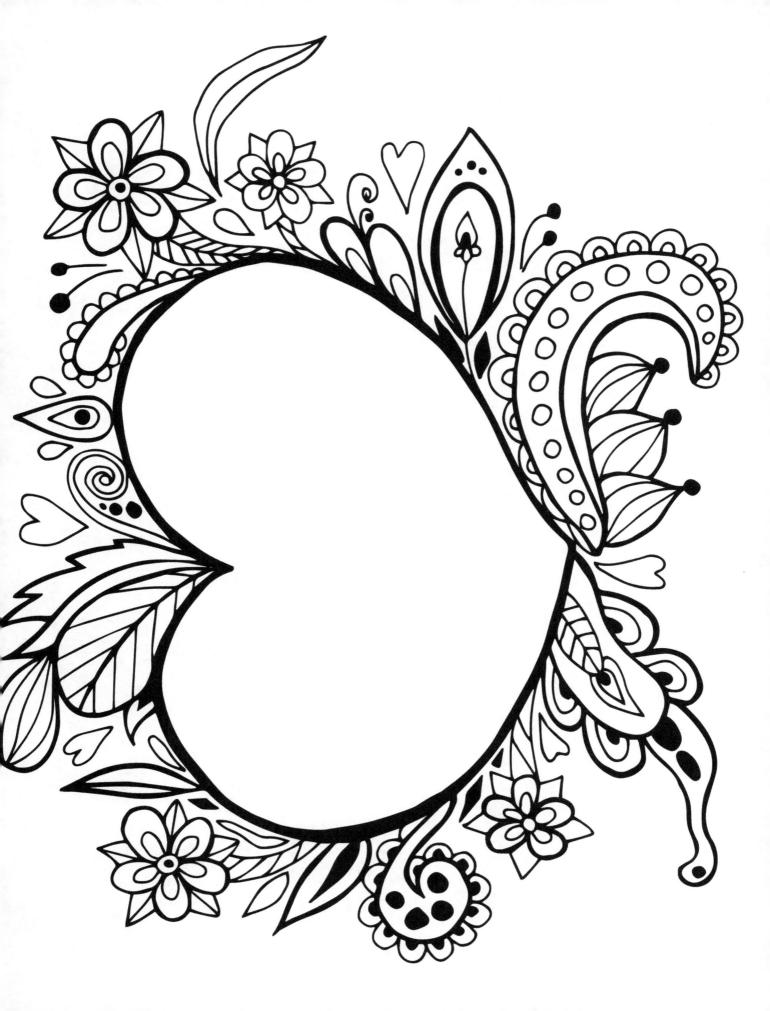

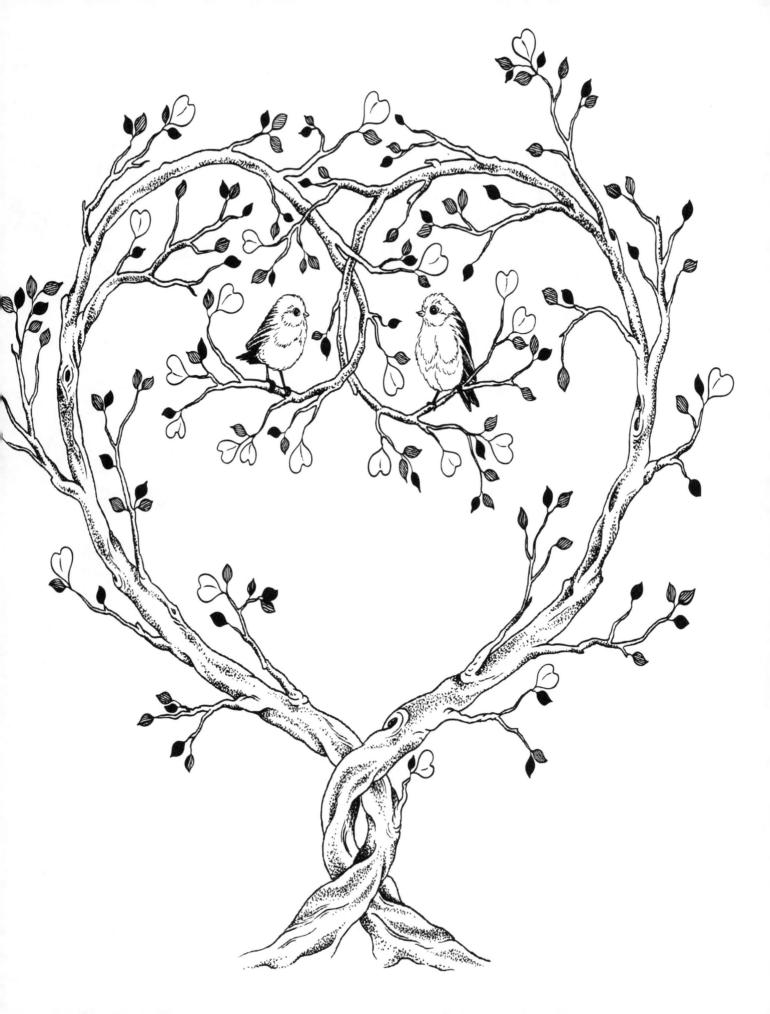

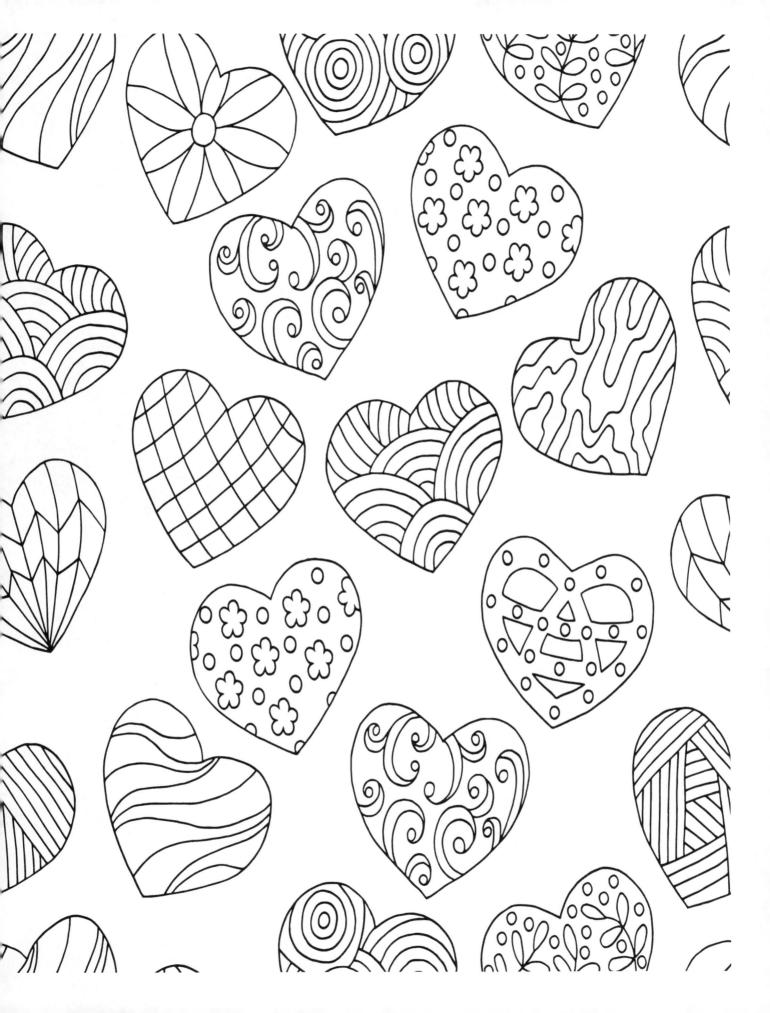

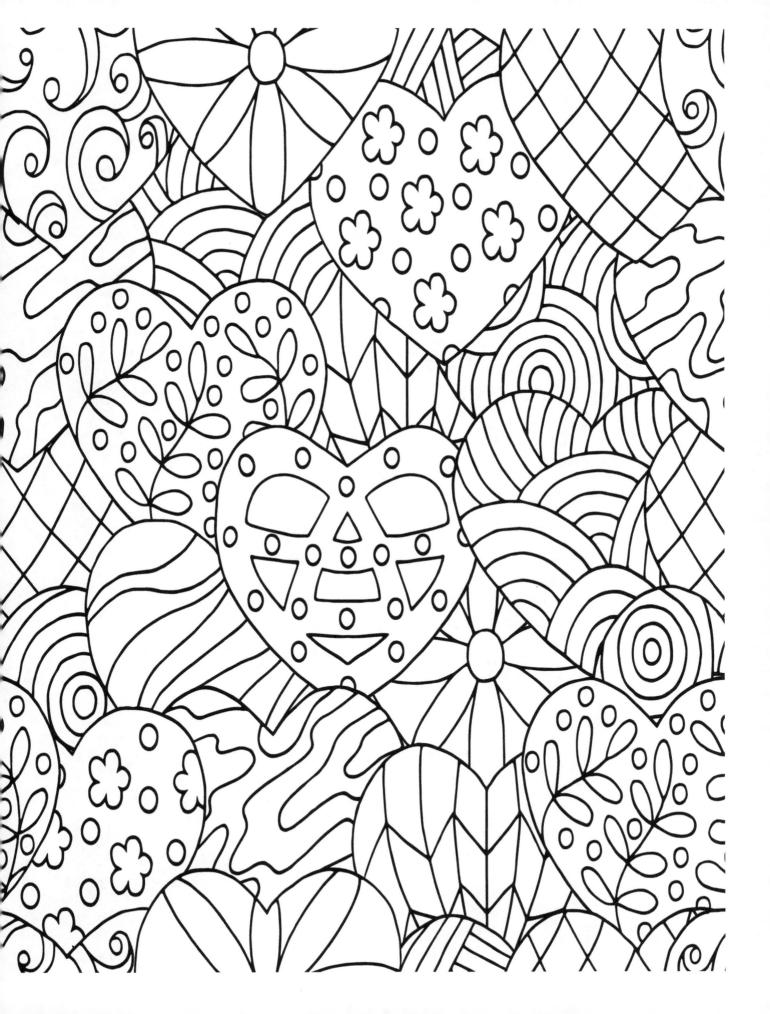

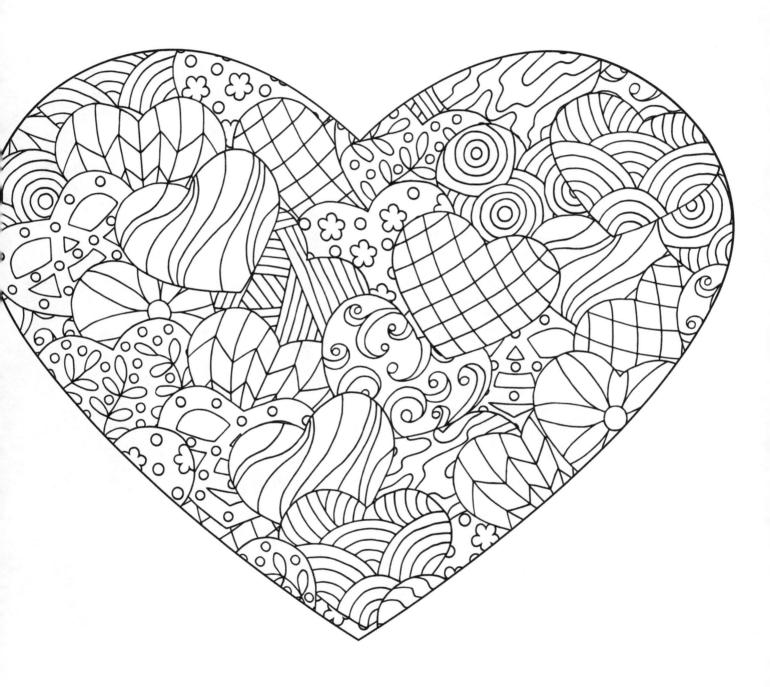

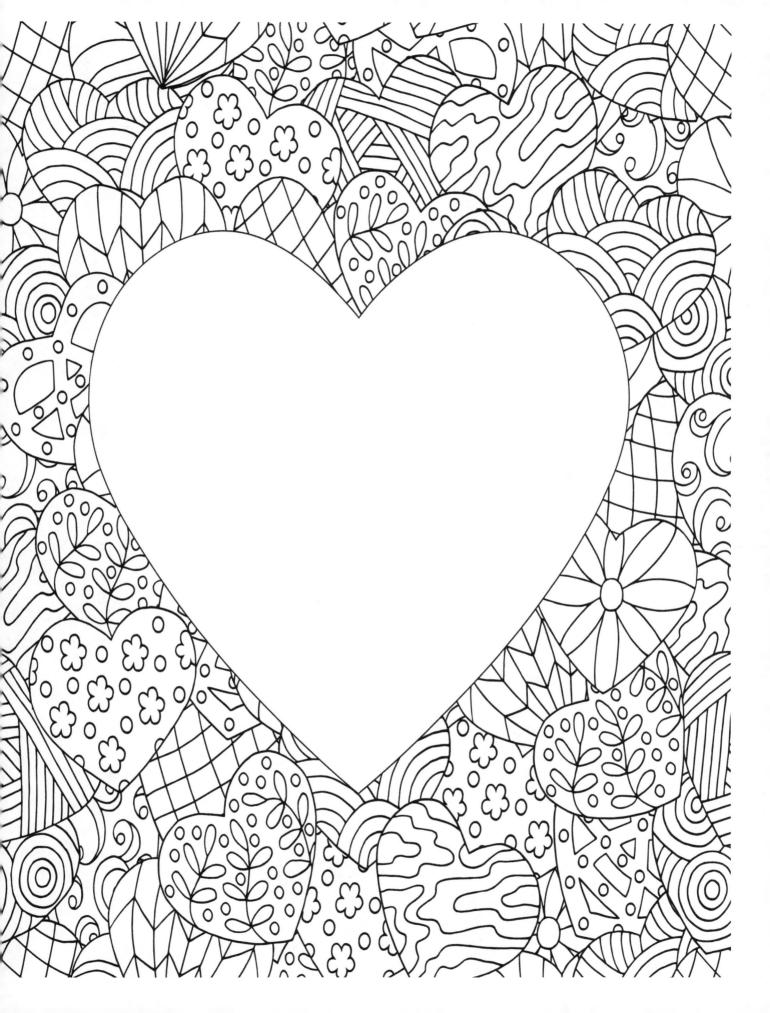

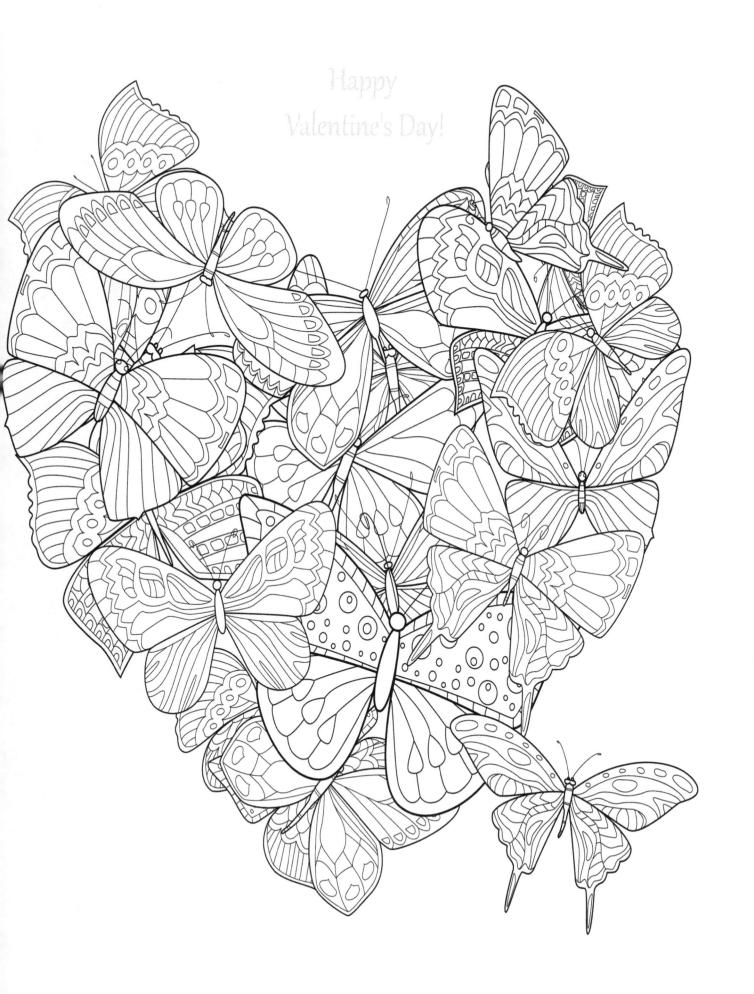

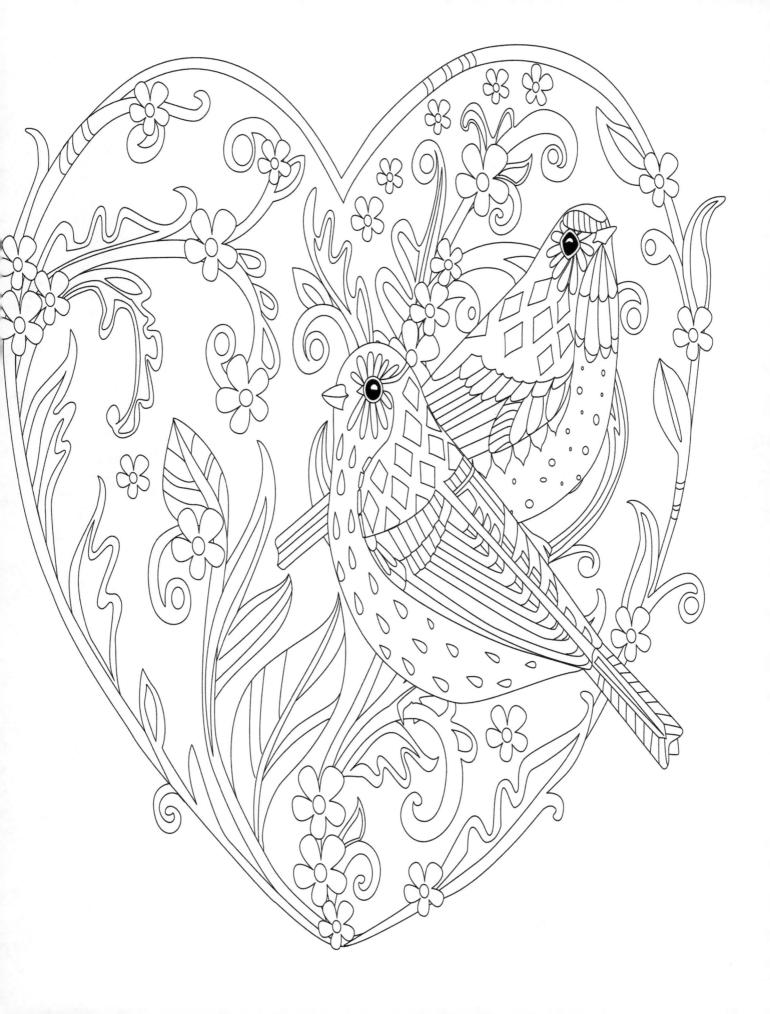

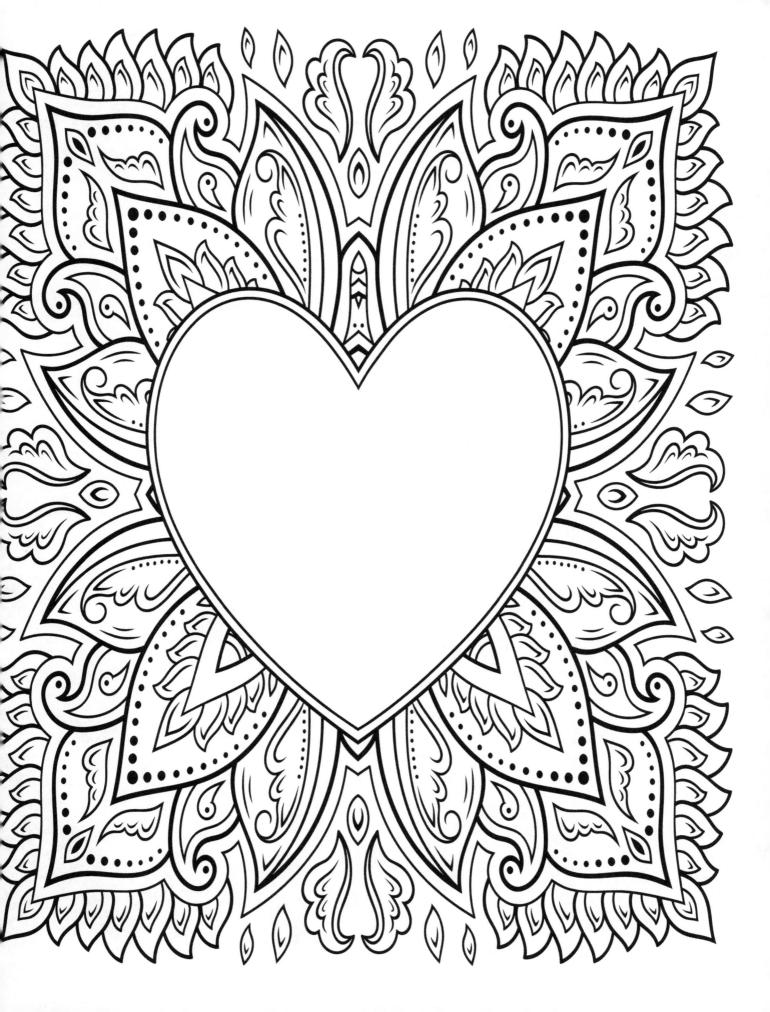

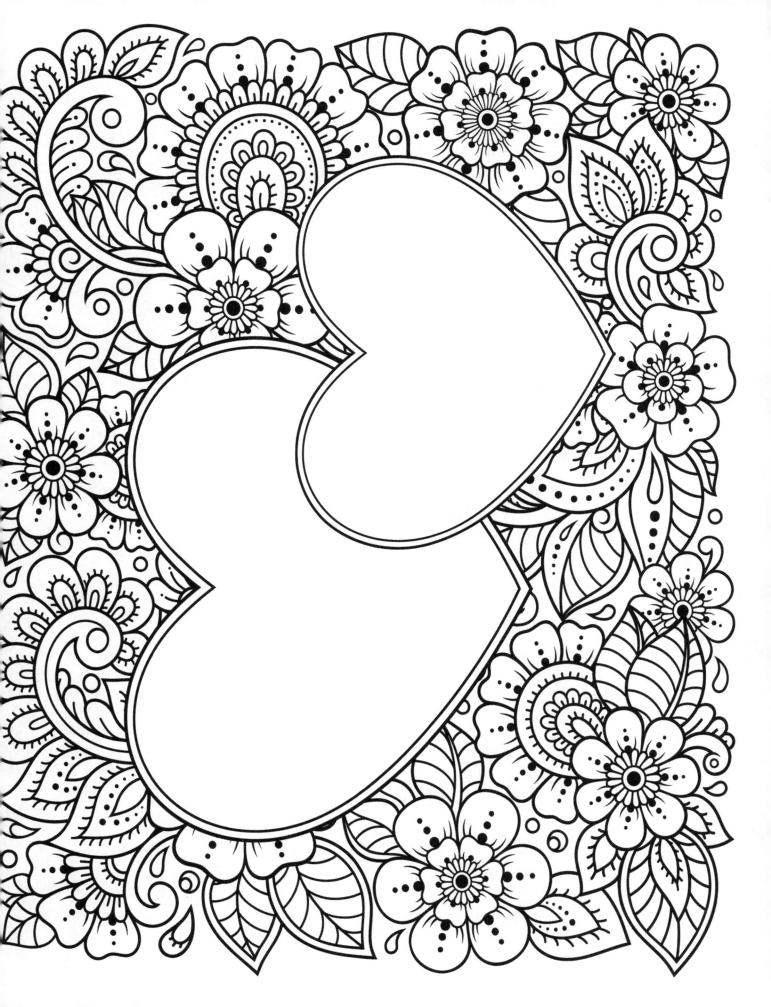

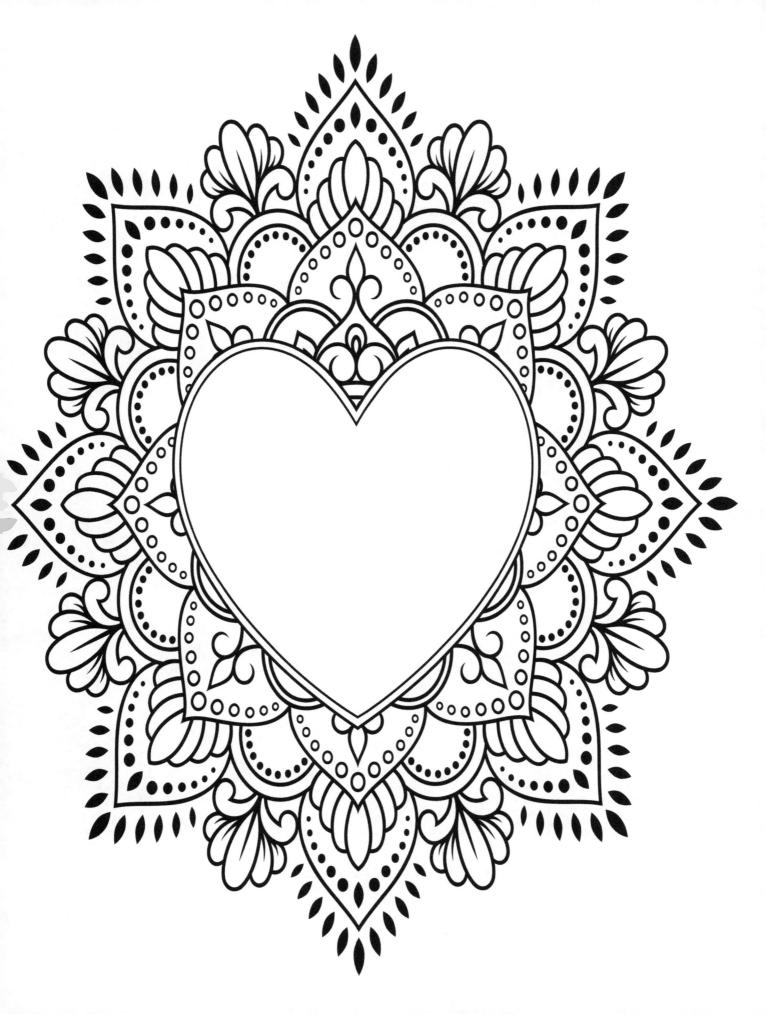

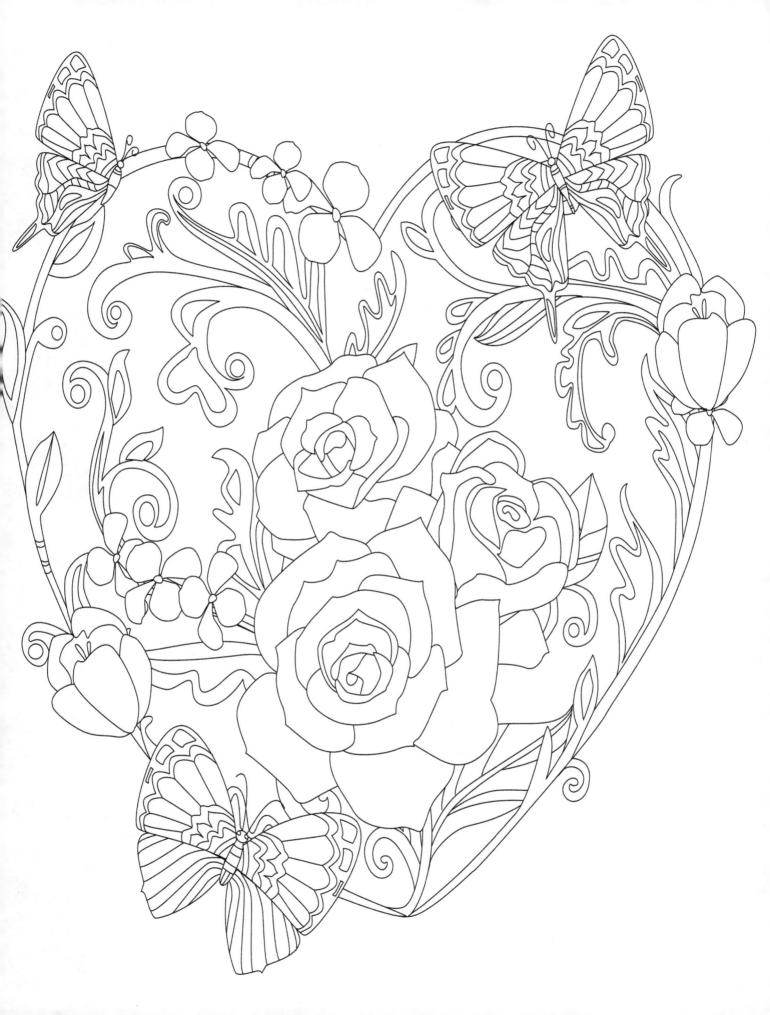

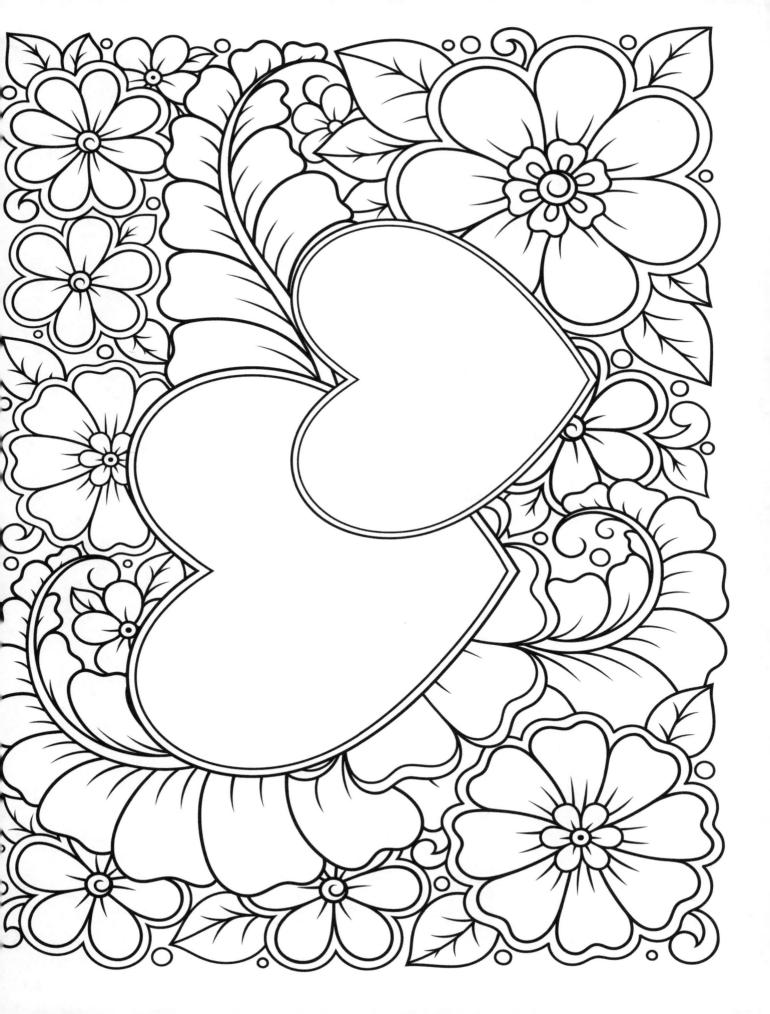

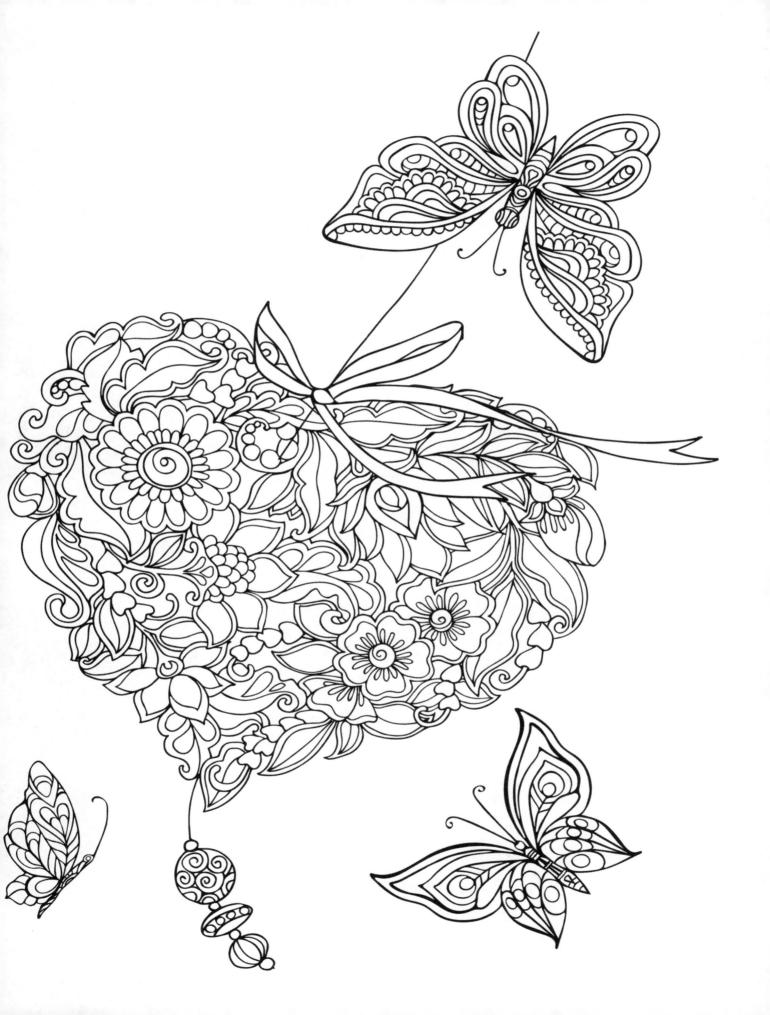

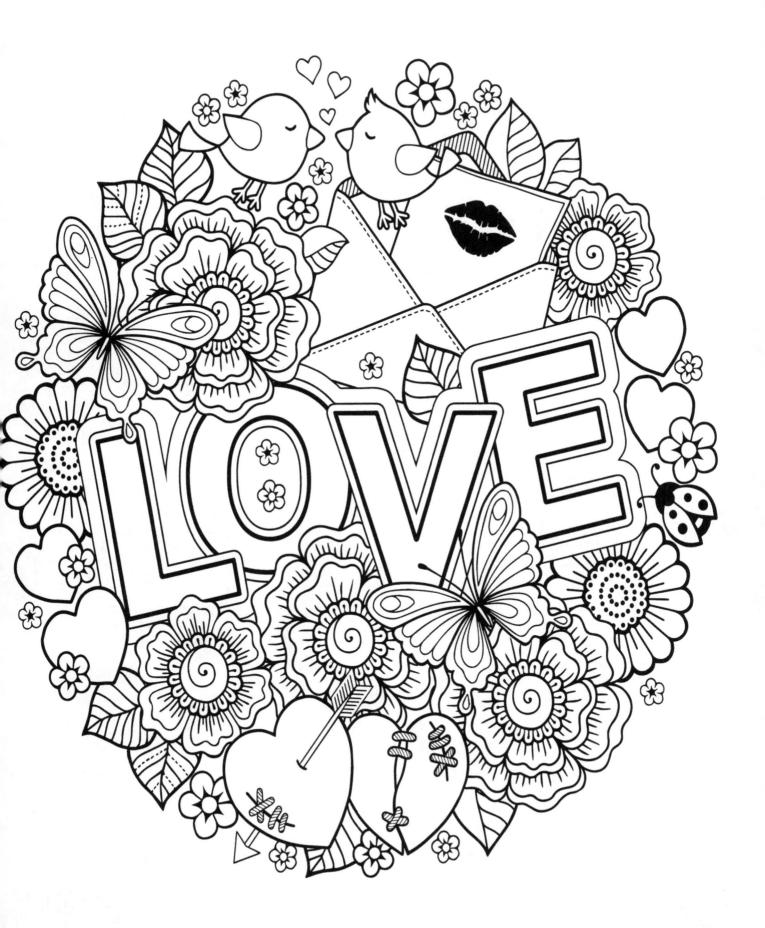